ORNAMENTAL
Pen Designs
and Flourishes

Selected and Arranged
by
Carol Belanger Grafton

DOVER PUBLICATIONS, INC.
Mineola, New York

Bibliographical Note

Ornamental Pen Designs and Flourishes is a new work, first published by Dover Publications, Inc., in 1996.

DOVER *Pictorial Archive* SERIES

This book belongs to the Dover Pictorial Archive Series. You may use the designs and illustrations for graphics and crafts applications, free and without special permission, provided that you include no more than four in the same publication or project. (For permission for additional use, please write to Dover Publications, Inc., 31 East 2nd Street, Mineola, N.Y. 11501.)

However, republication or reproduction of any illustration by any other graphic service whether it be in a book or in any other design resource is strictly prohibited.

Library of Congress Cataloging-in-Publication Data

Grafton, Carol Belanger.
 Ornamental pen designs and flourishes / selected and arranged by Carol Belanger Grafton.
 p. cm. — (Dover pictorial archive series)
 ISBN 0-486-29388-2 (pbk.)
 1. Calligraphy—Themes, motives. I. Title. II. Series.
NK3630.G72 1996
745.6′1—dc20
 96-25993
 CIP

Manufactured in the United States of America
Dover Publications, Inc., 31 East 2nd Street, Mineola, N.Y. 11501

Note

Designer **Carol Belanger Grafton** has culled over 300 ornate pen flourishes from late nineteenth-century books and periodicals, such as *The Penman's Art Journal; The Penman's Paradise; Real Pen Work; Ames's New Compendium of Practical and Artistic Penmanship; Calligraphy; Ornamental Penmanship; Master Album of Pictorial Calligraphy and Scrollwork; Ornamental Calligraphy* and many others. Fancifully wrought, the images include a wide array of subjects: angels, griffins, birds, fish, horses, scrolled ornaments and more. Artists and craftsworkers will find this anthology—with its copyright-free designs—an invaluable resource.

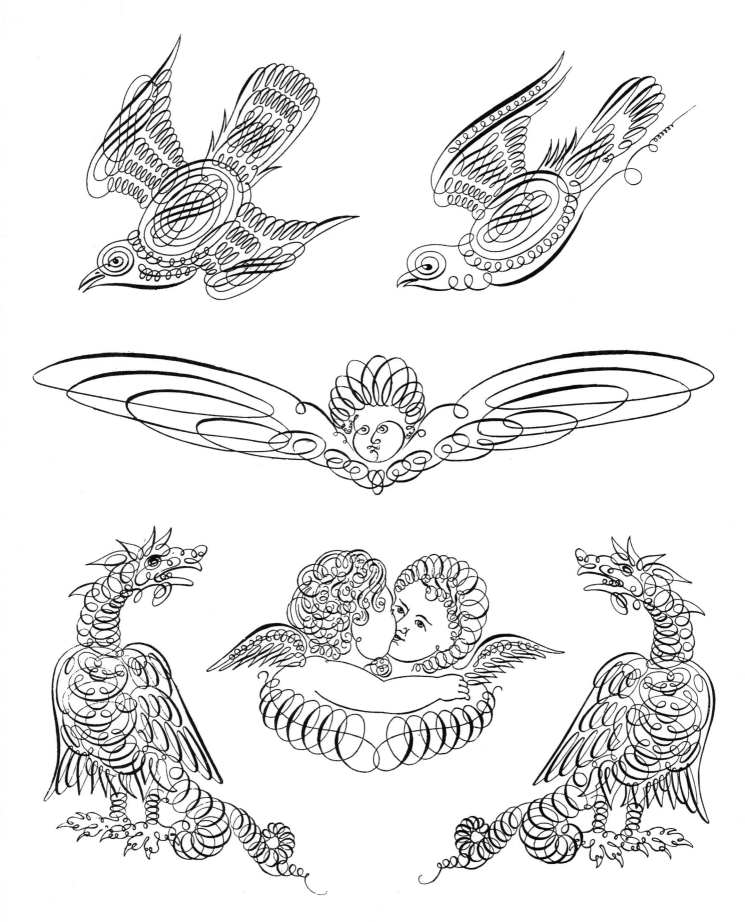

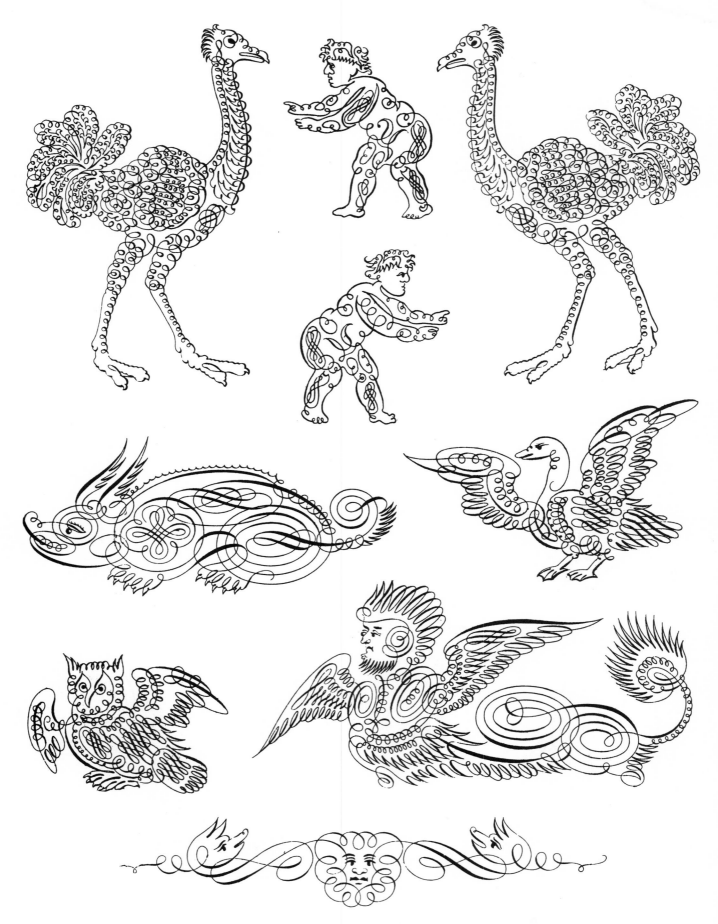

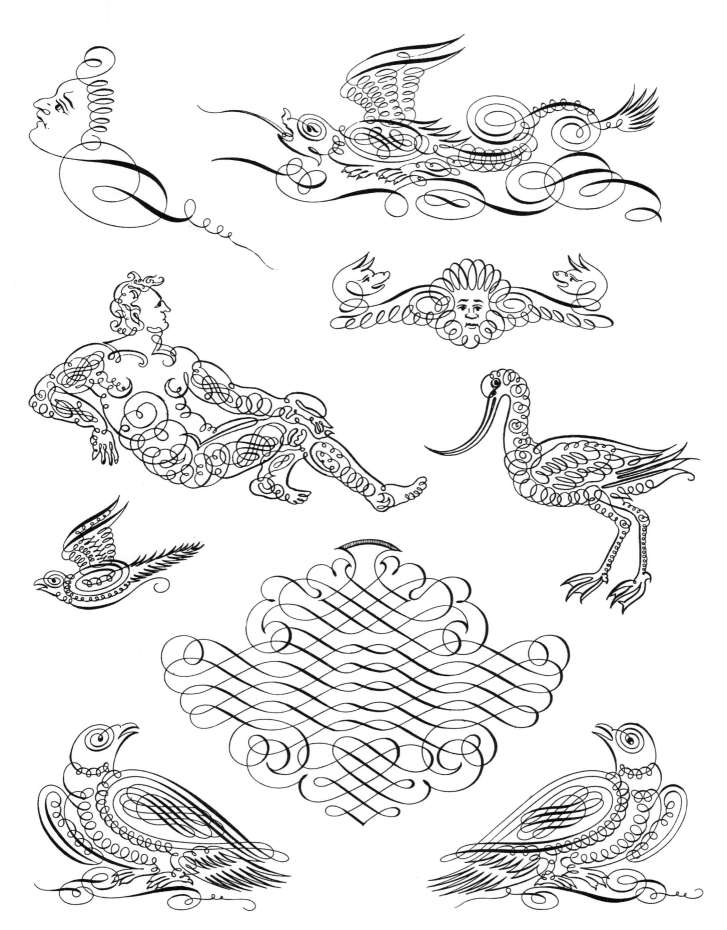

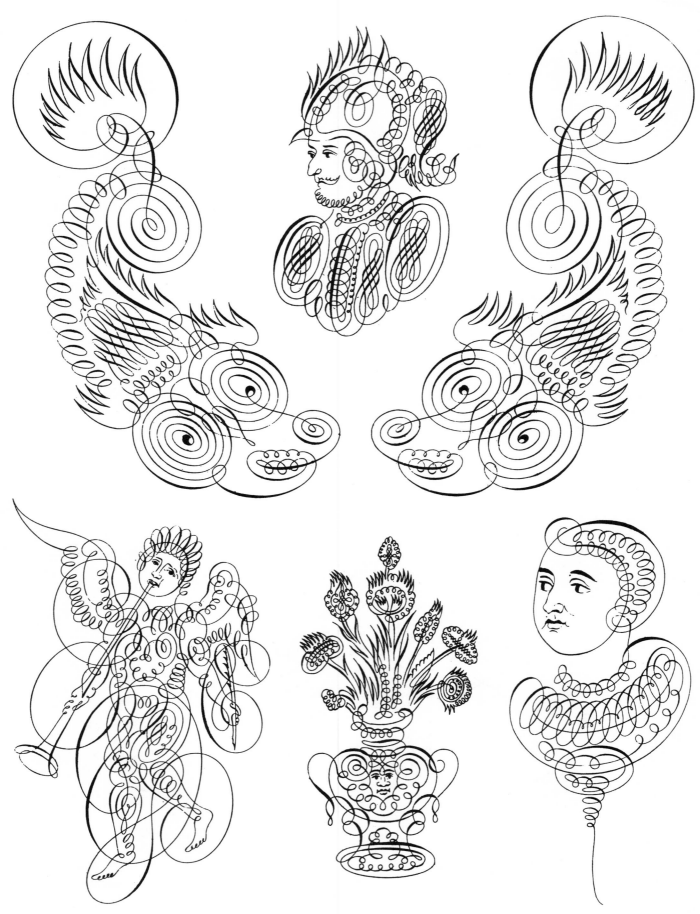

4

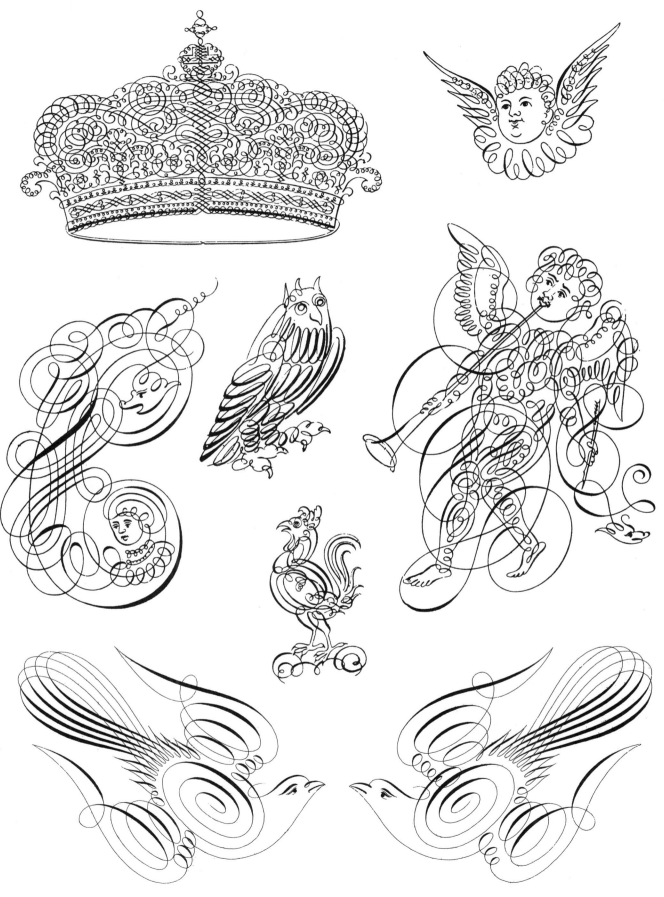

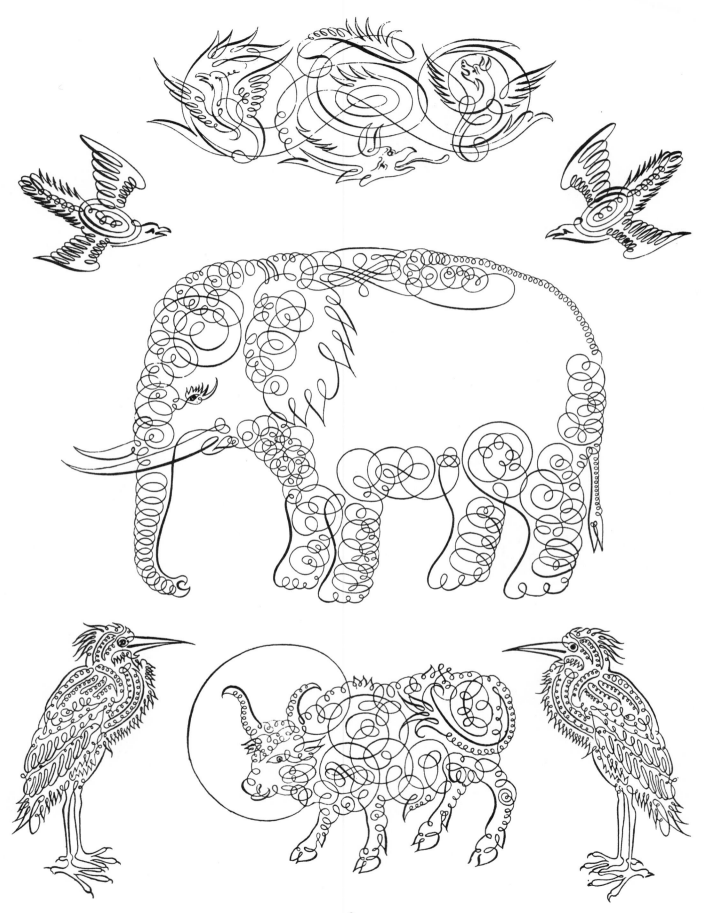

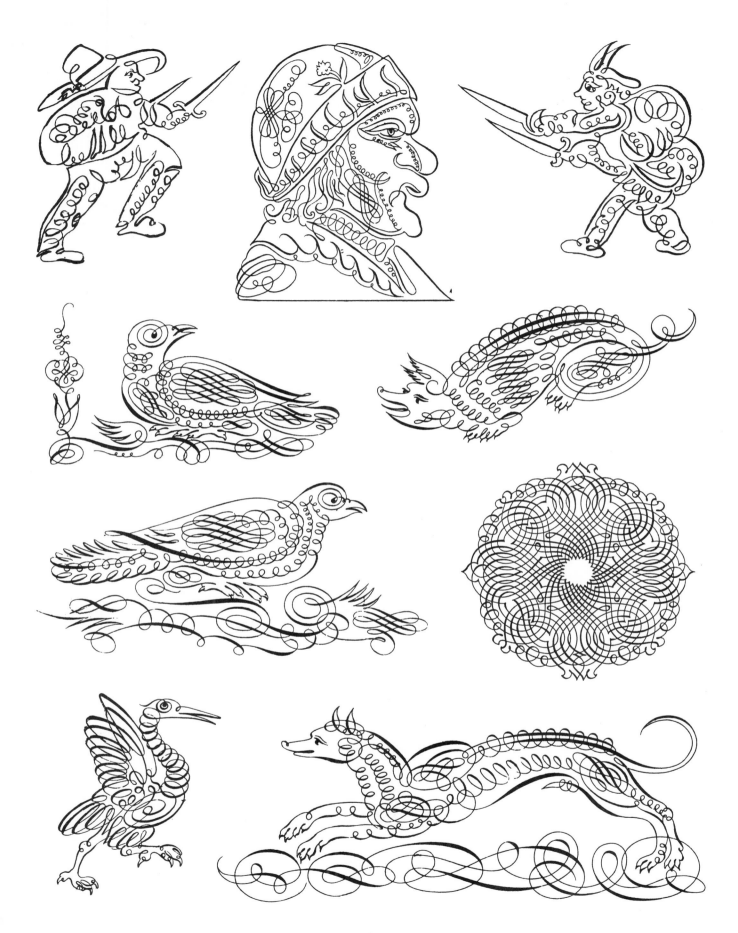

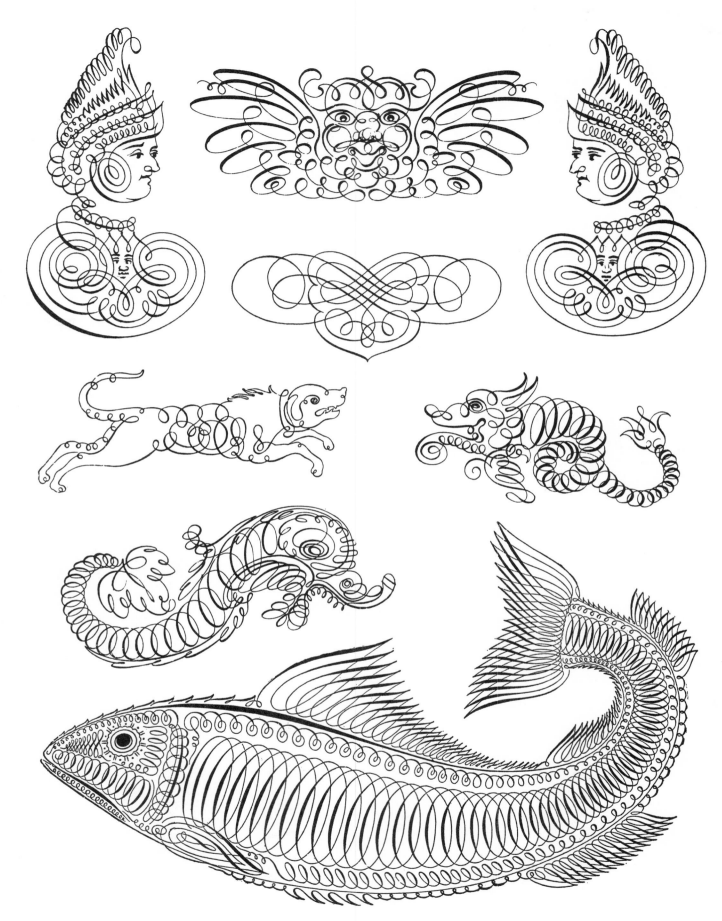

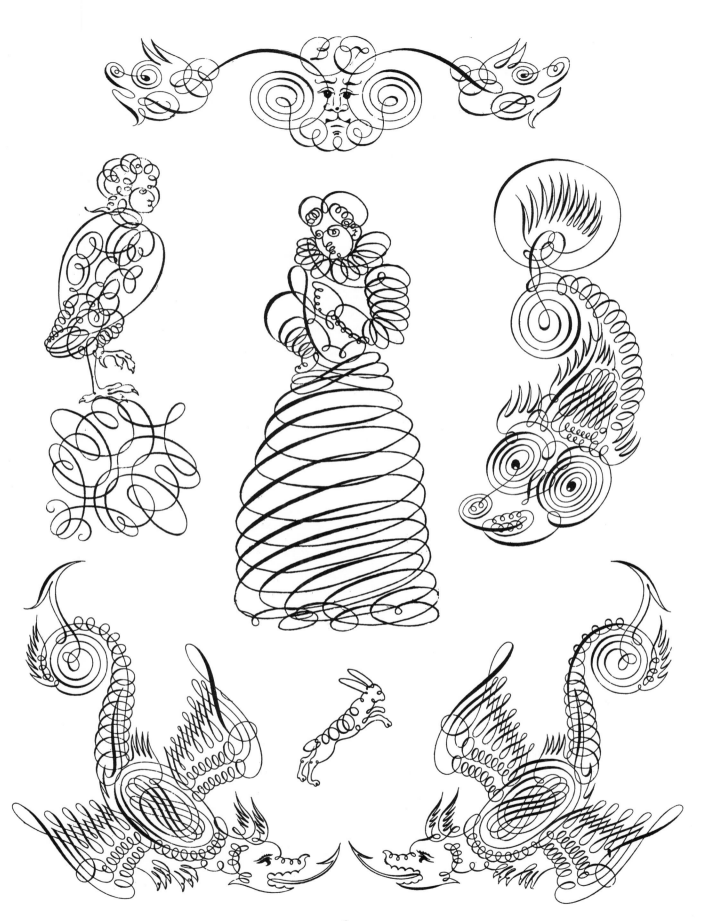

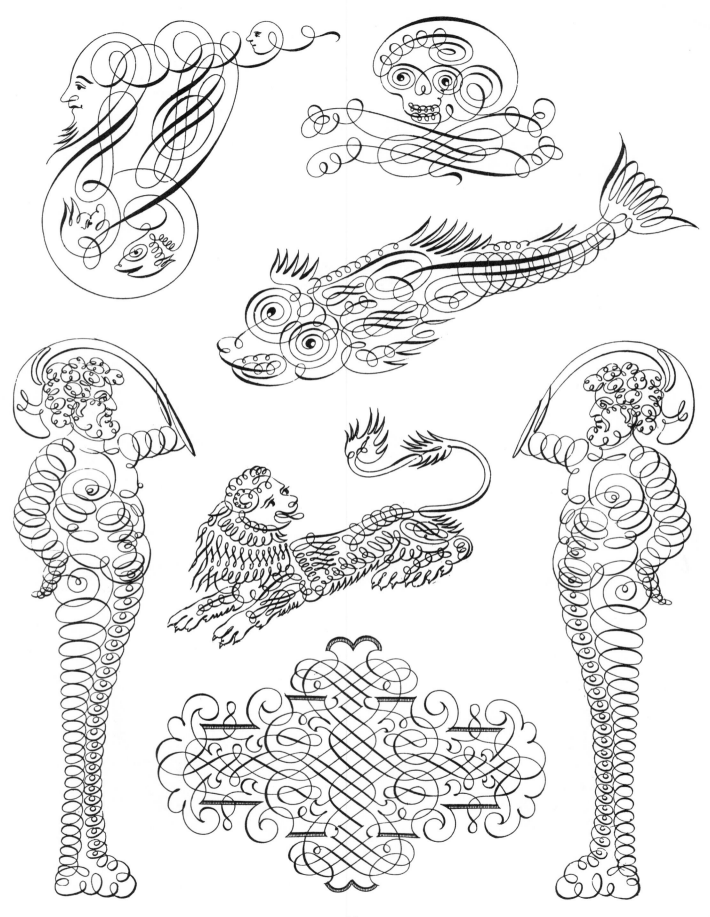

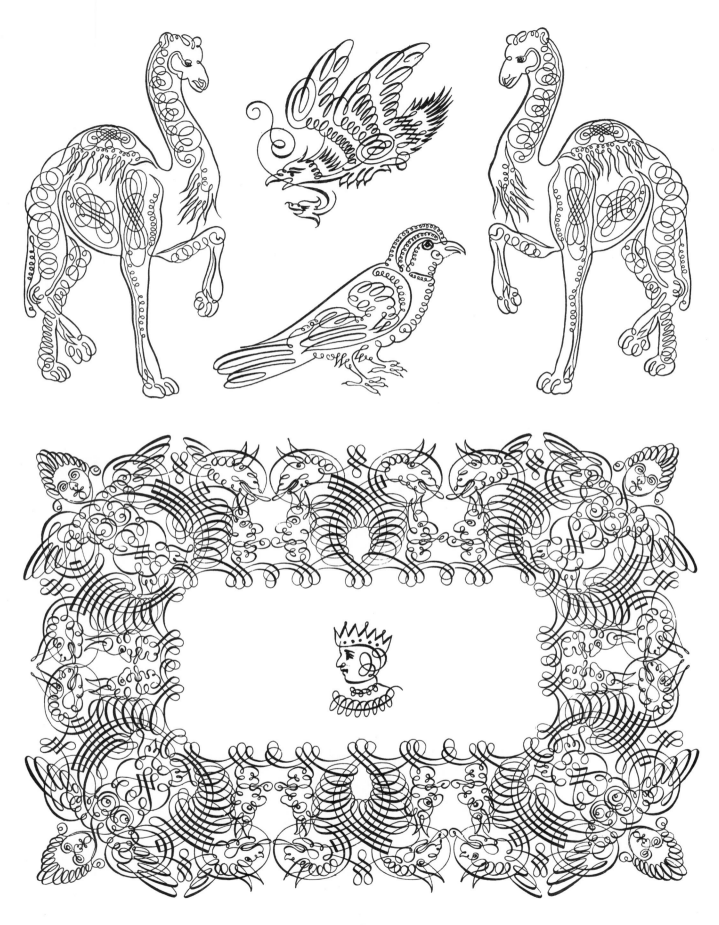

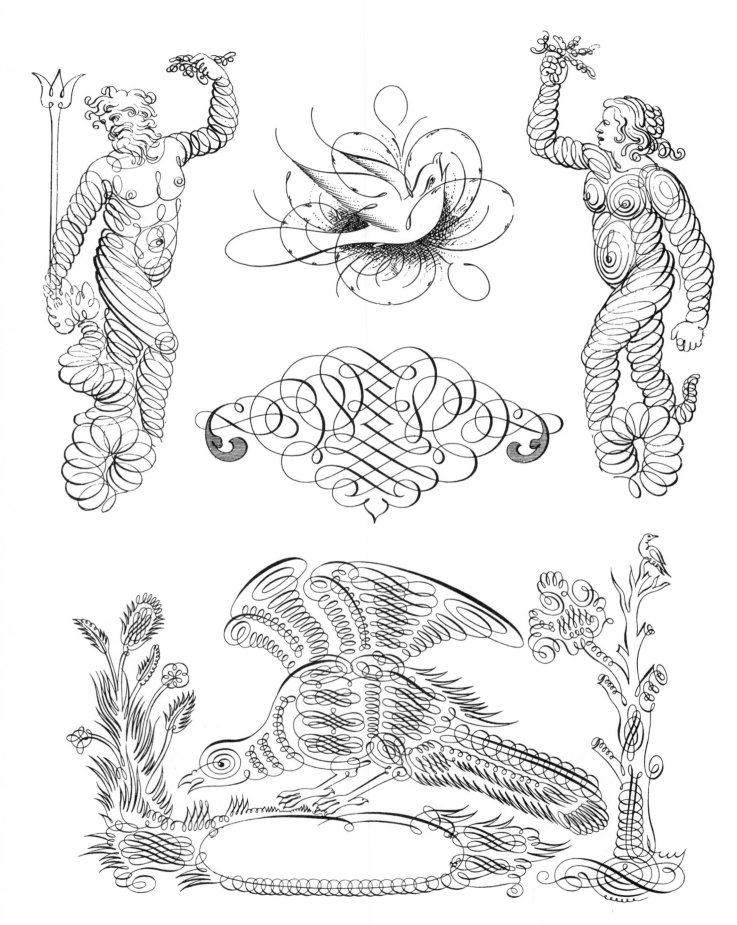

12

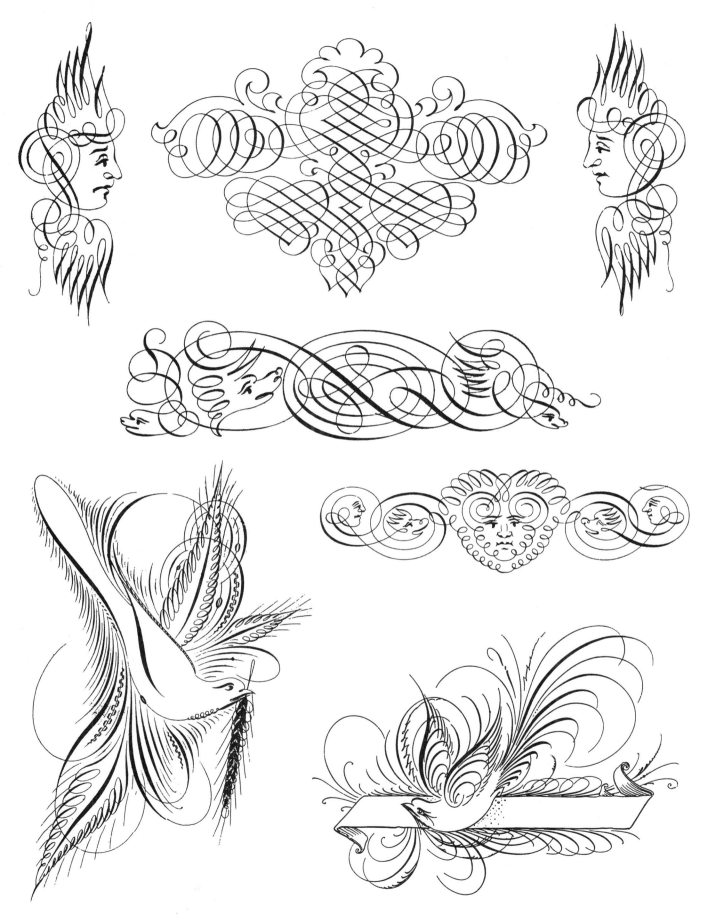

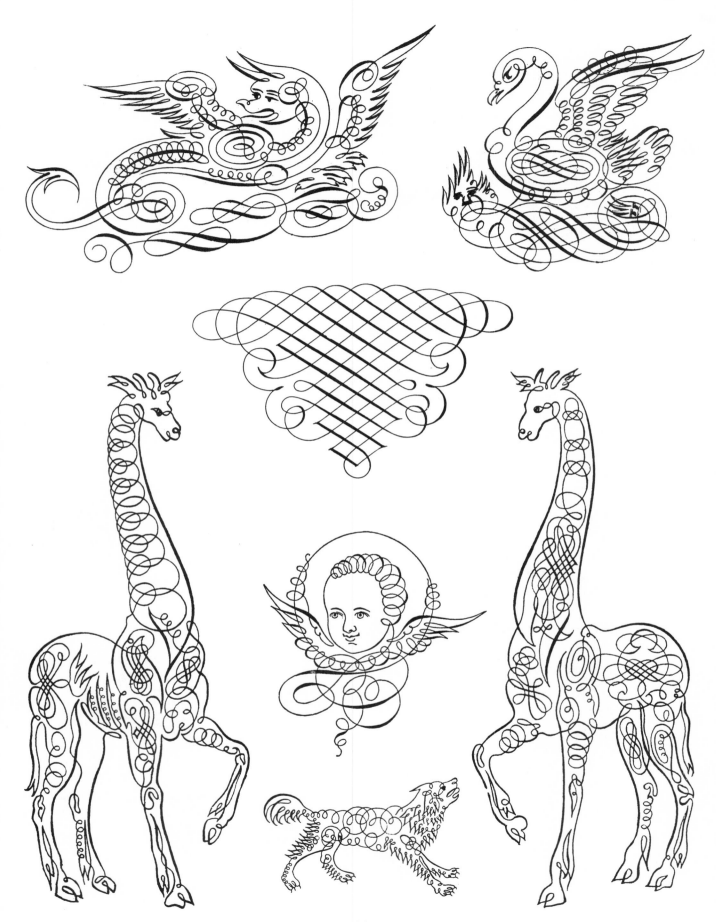

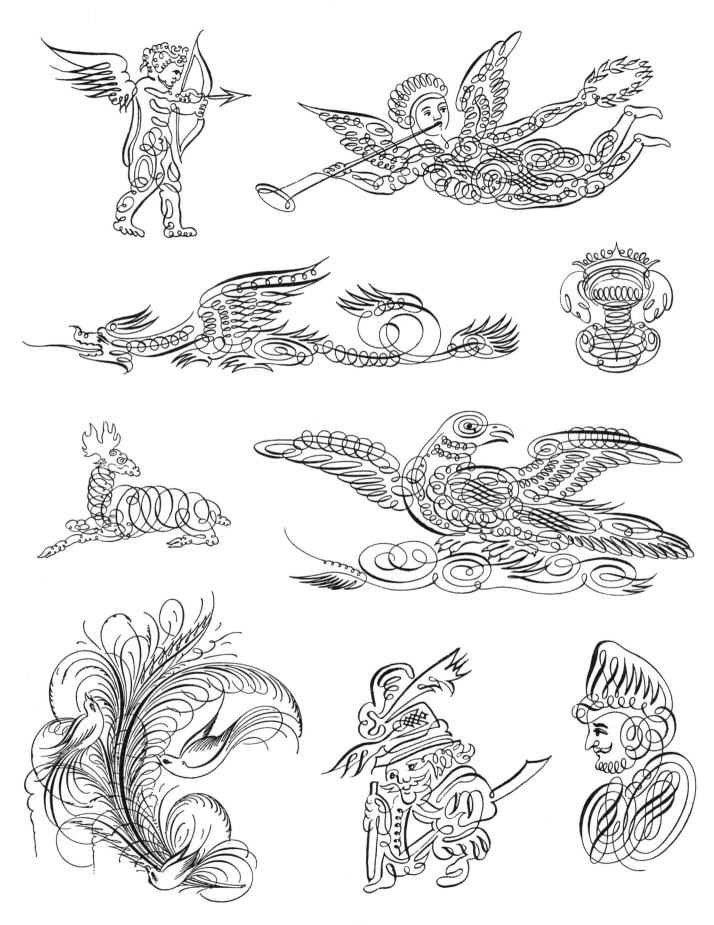

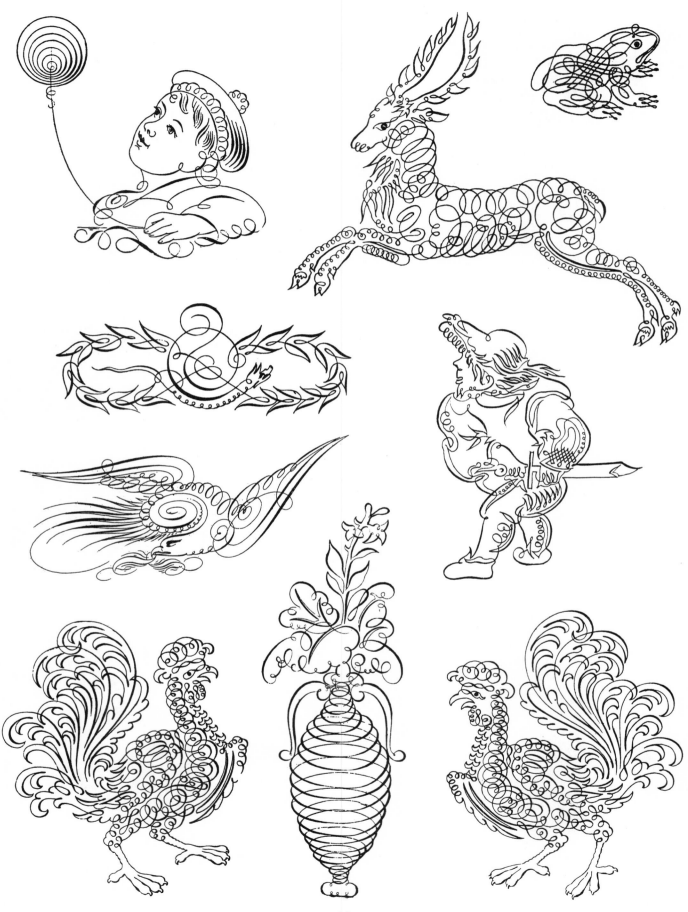

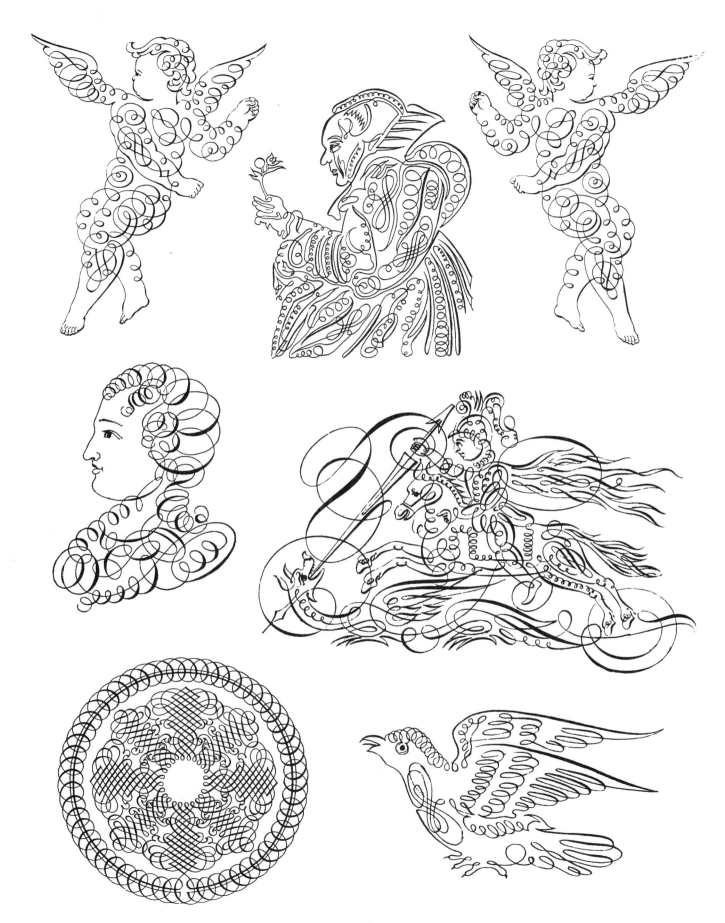

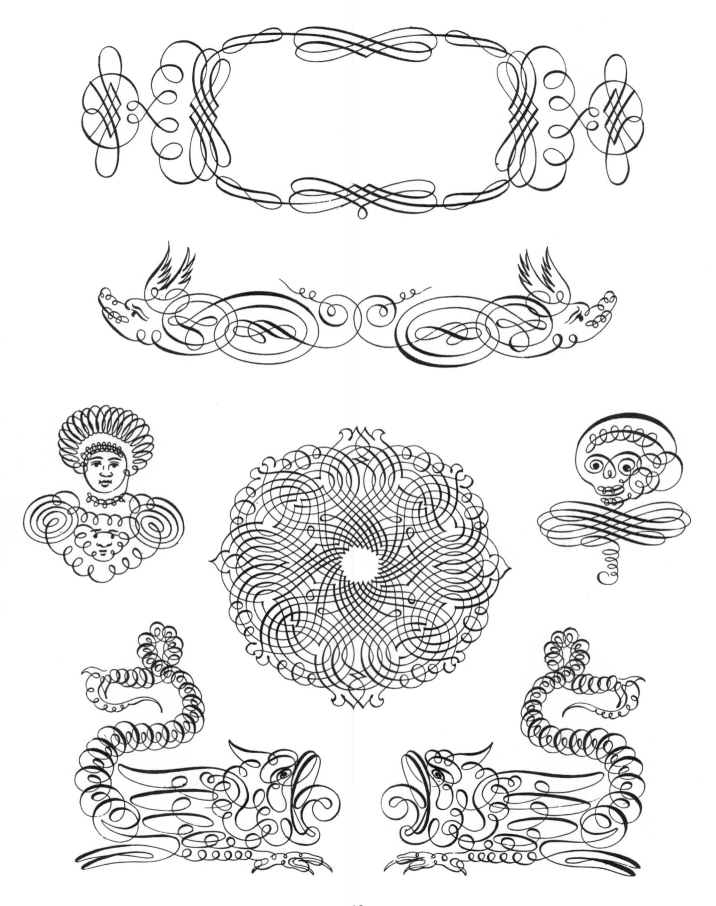

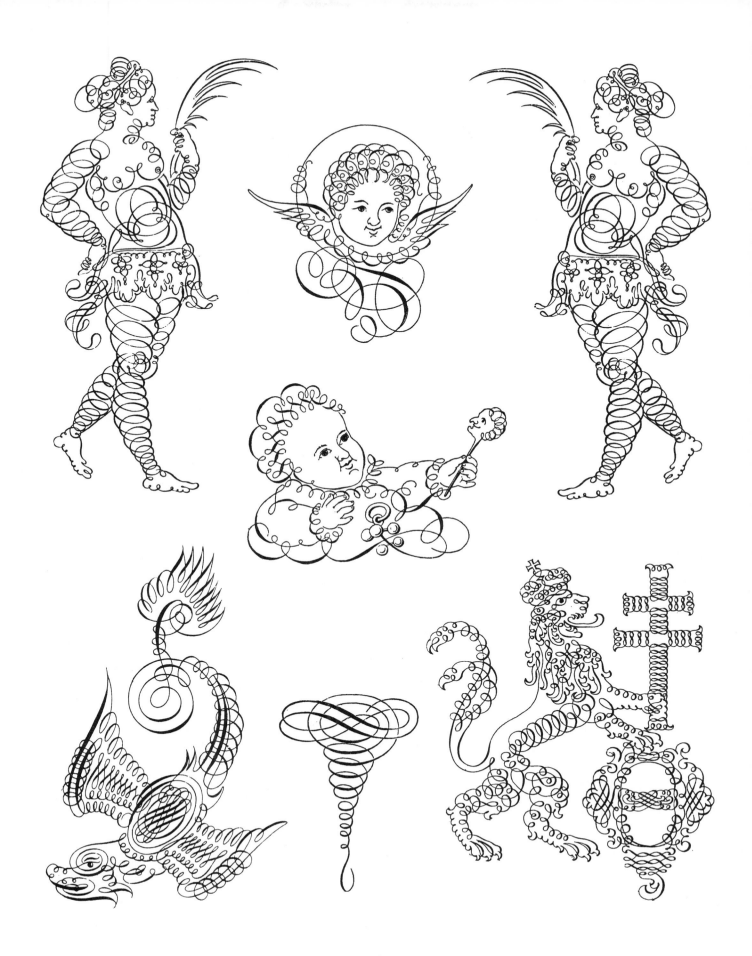

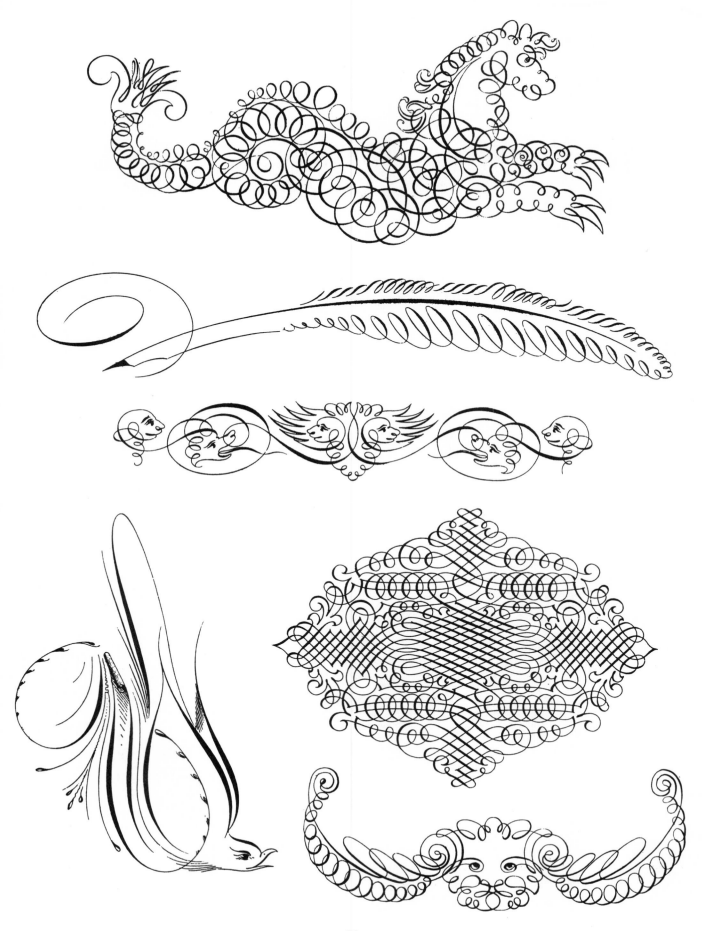

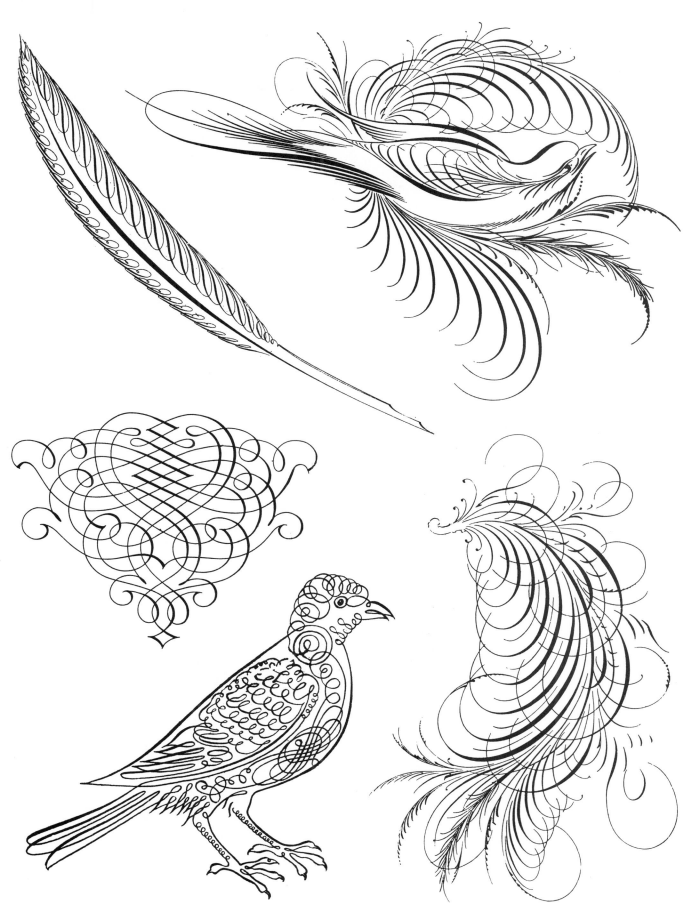

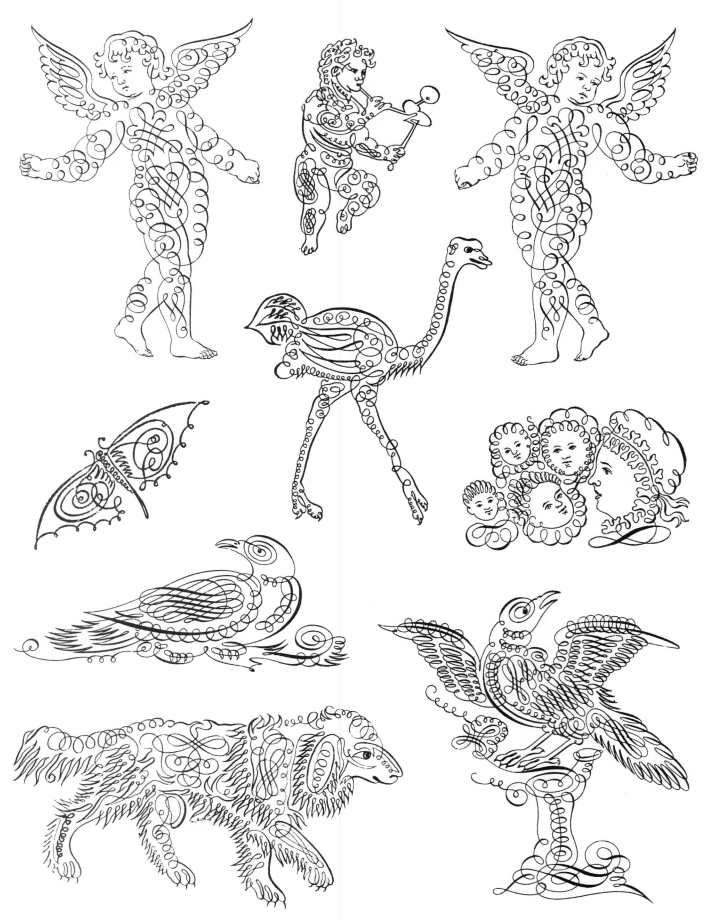

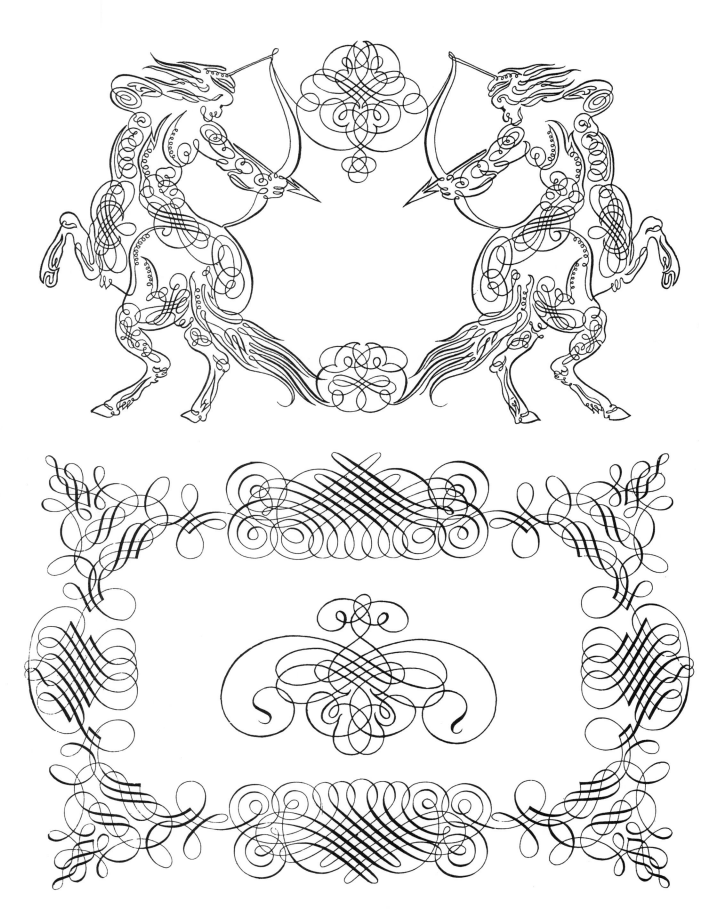

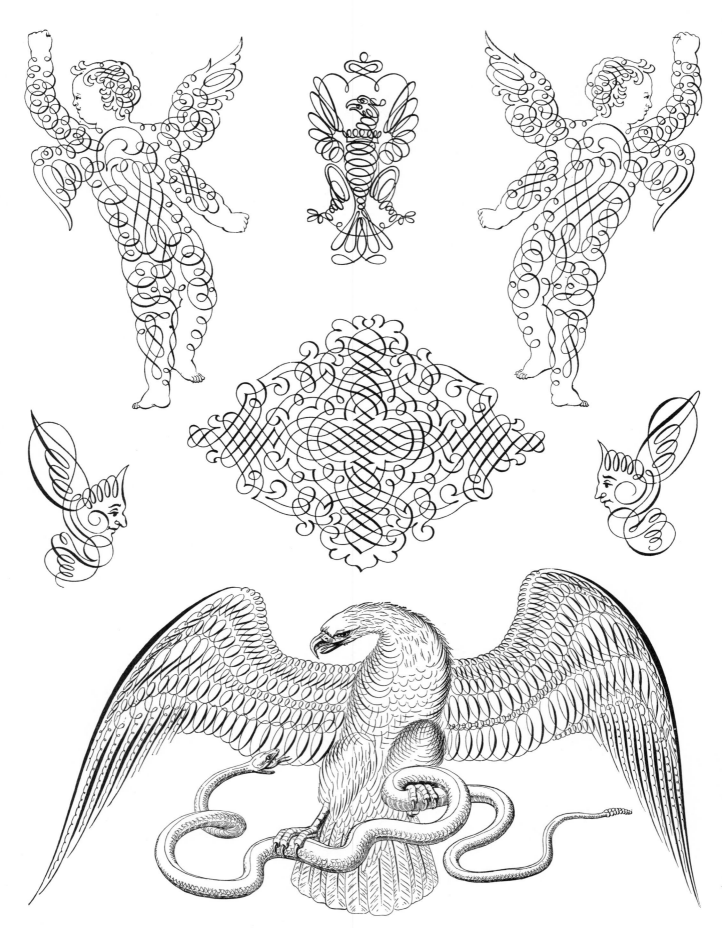

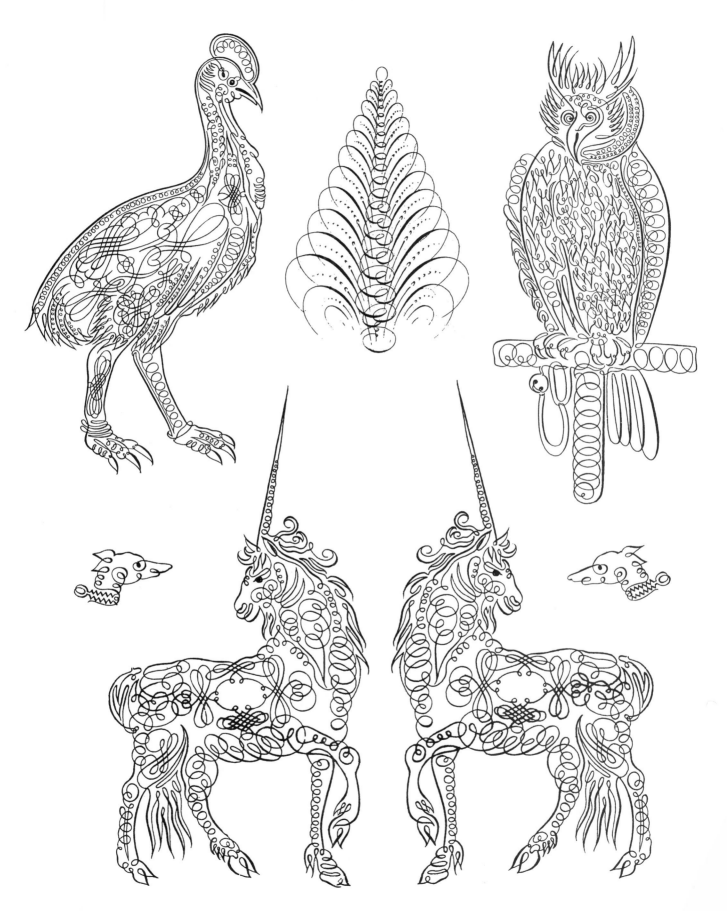

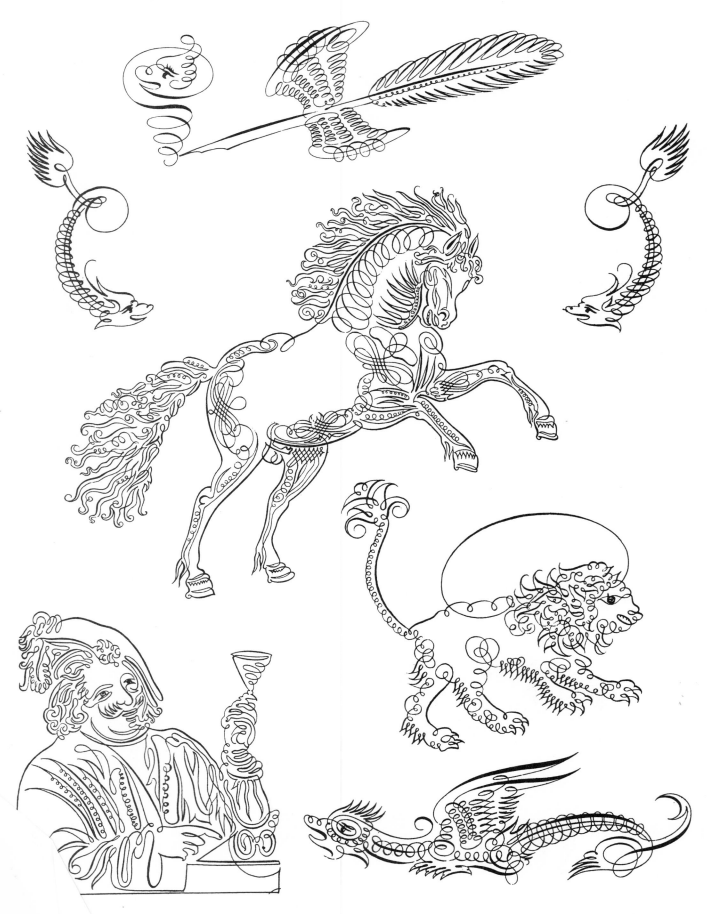

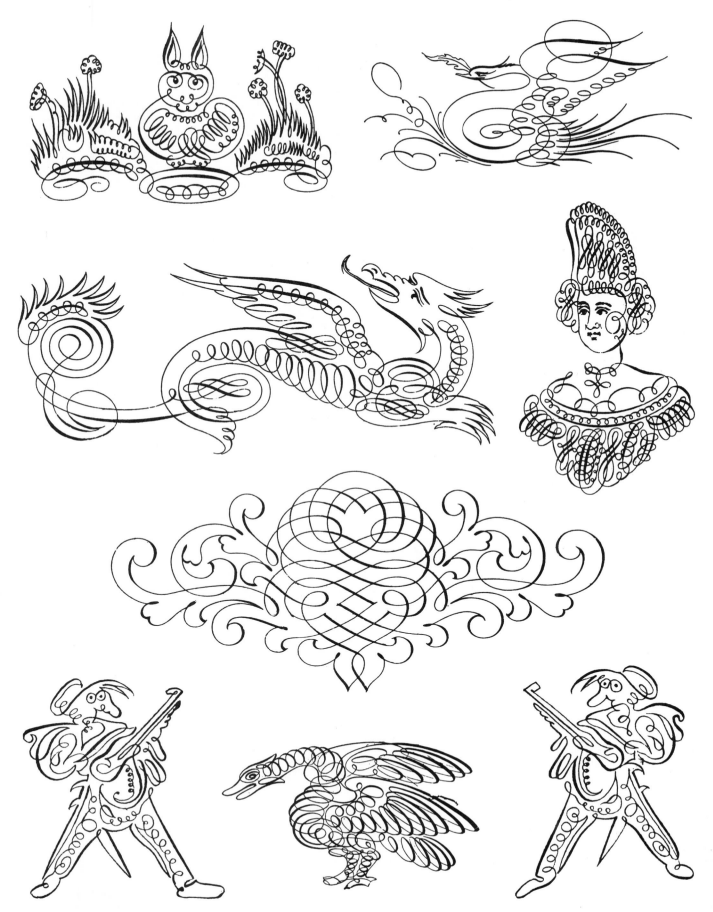

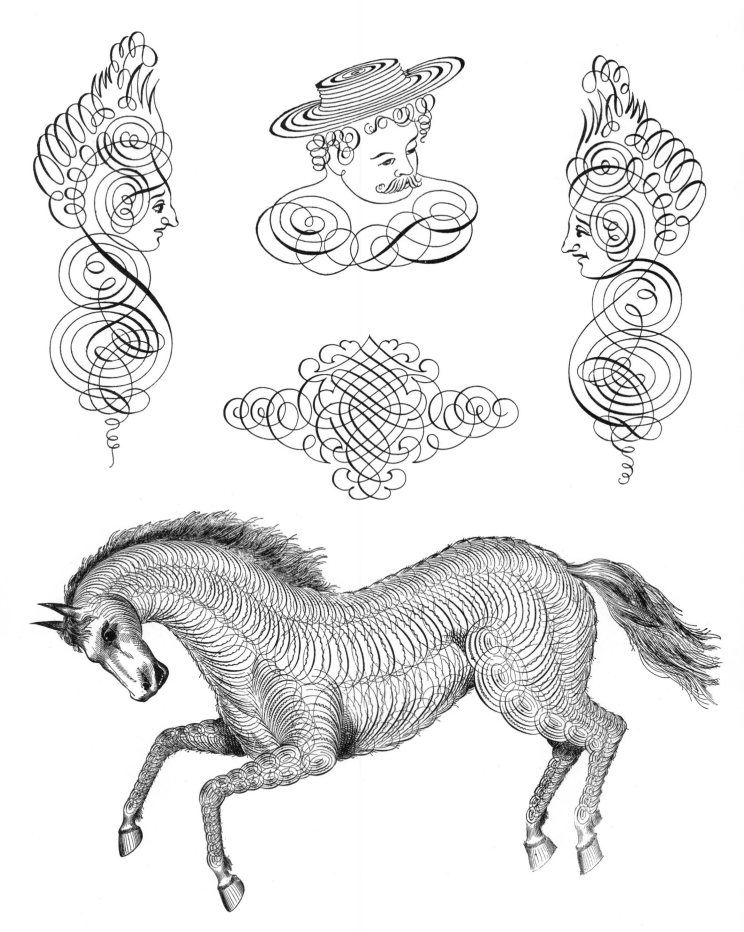

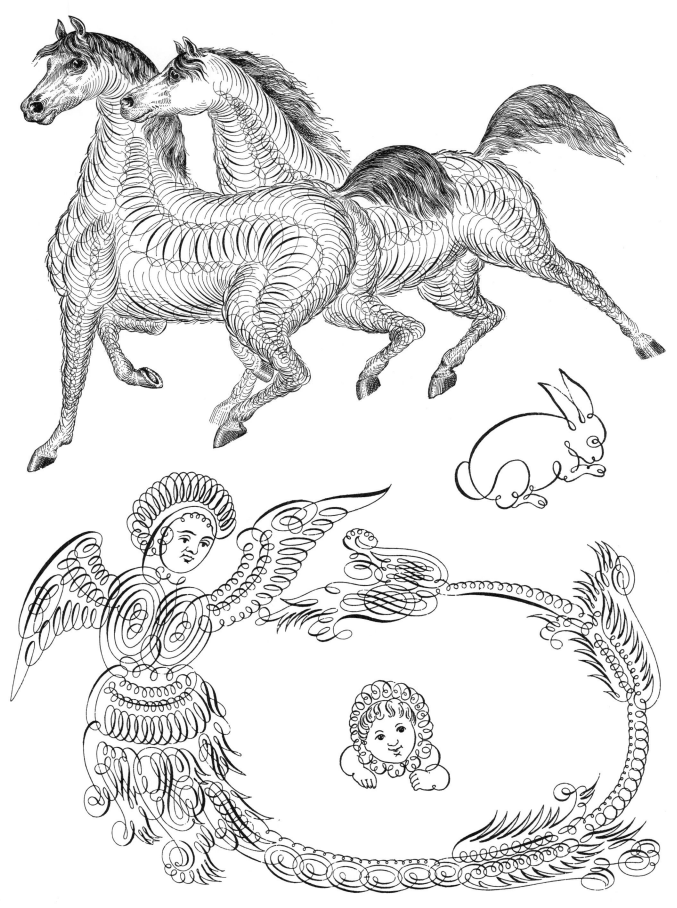

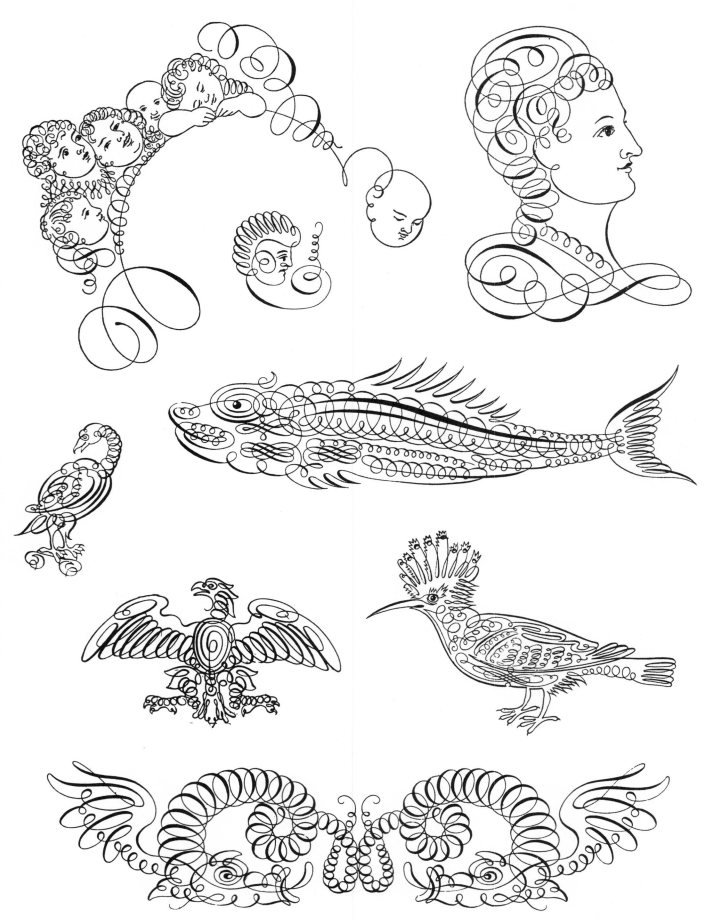

30

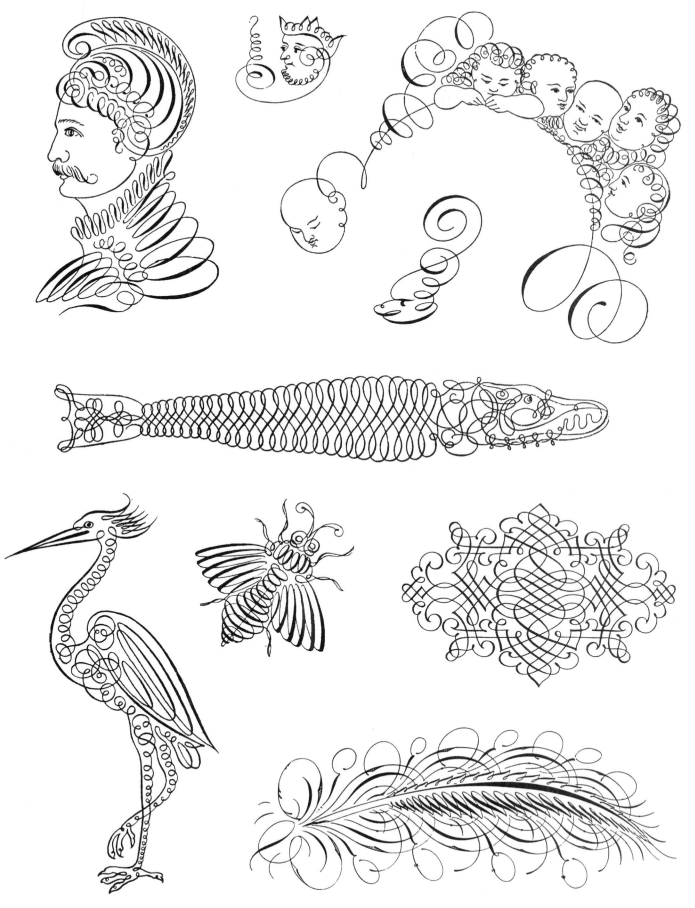

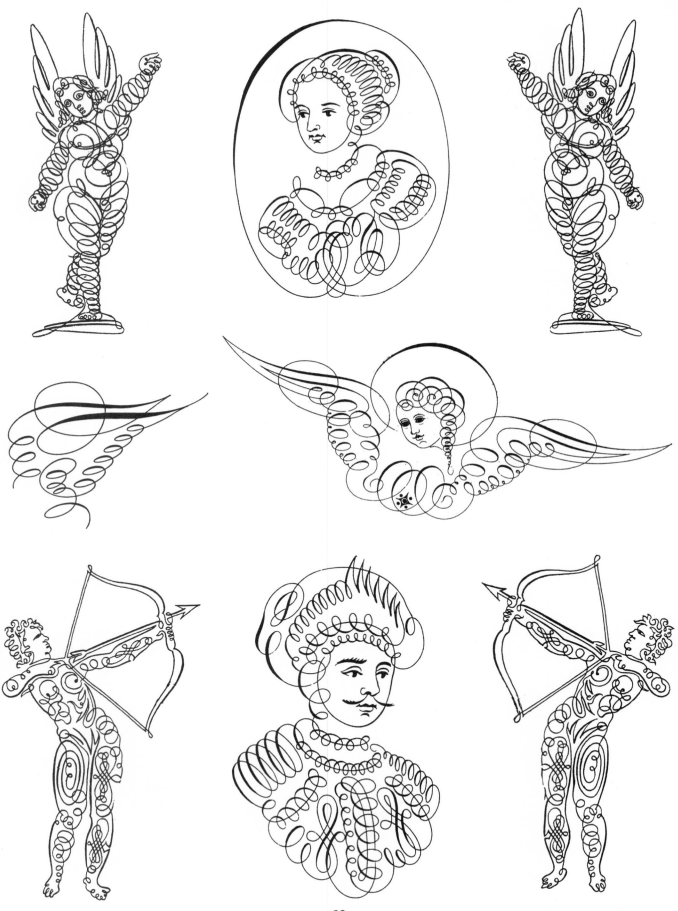

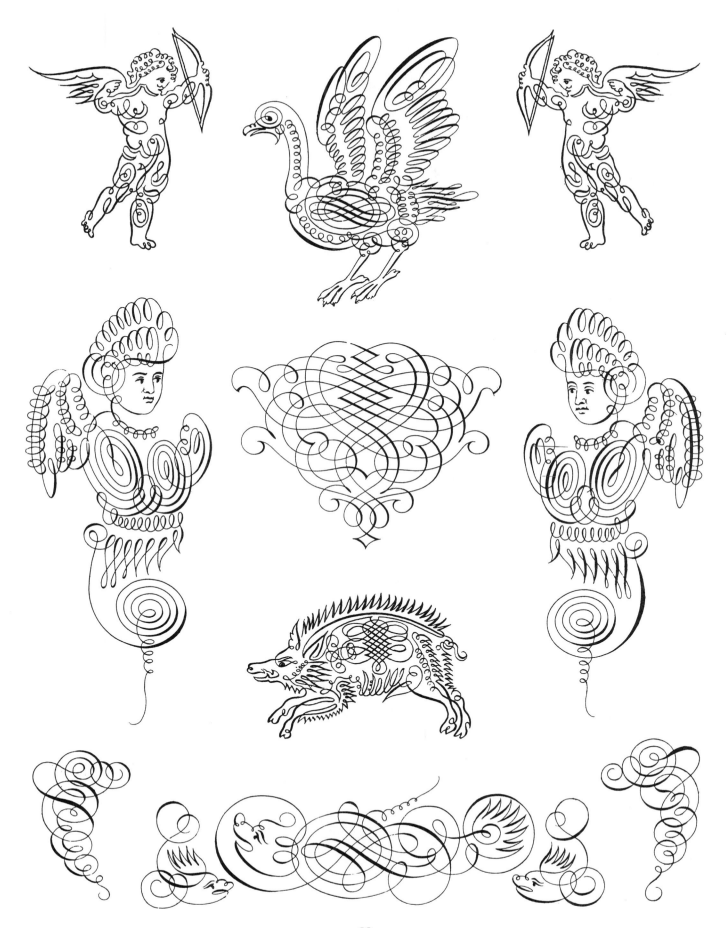

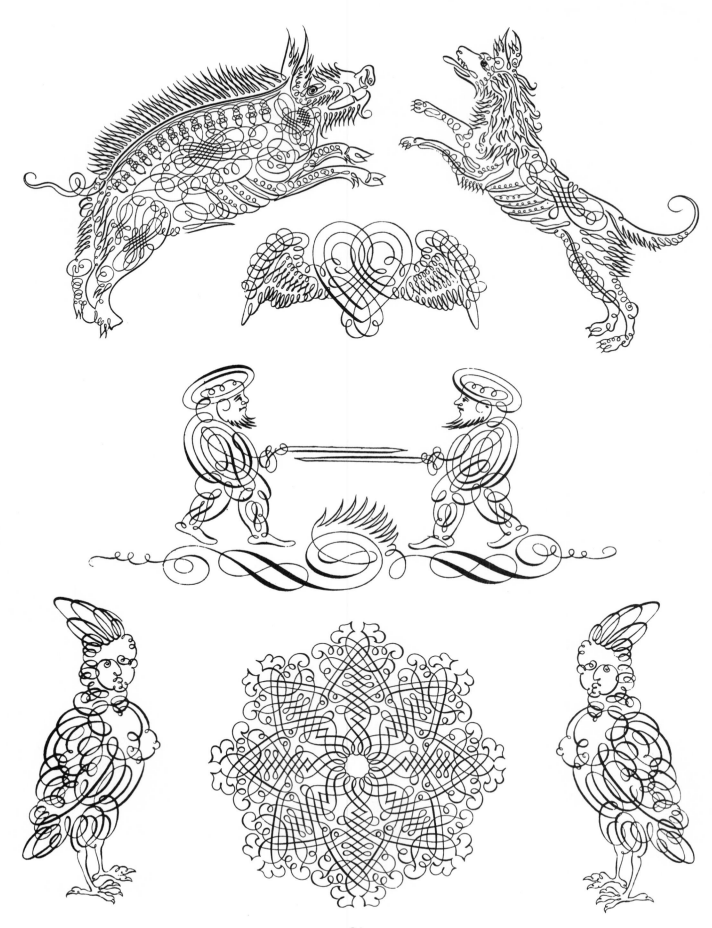

34

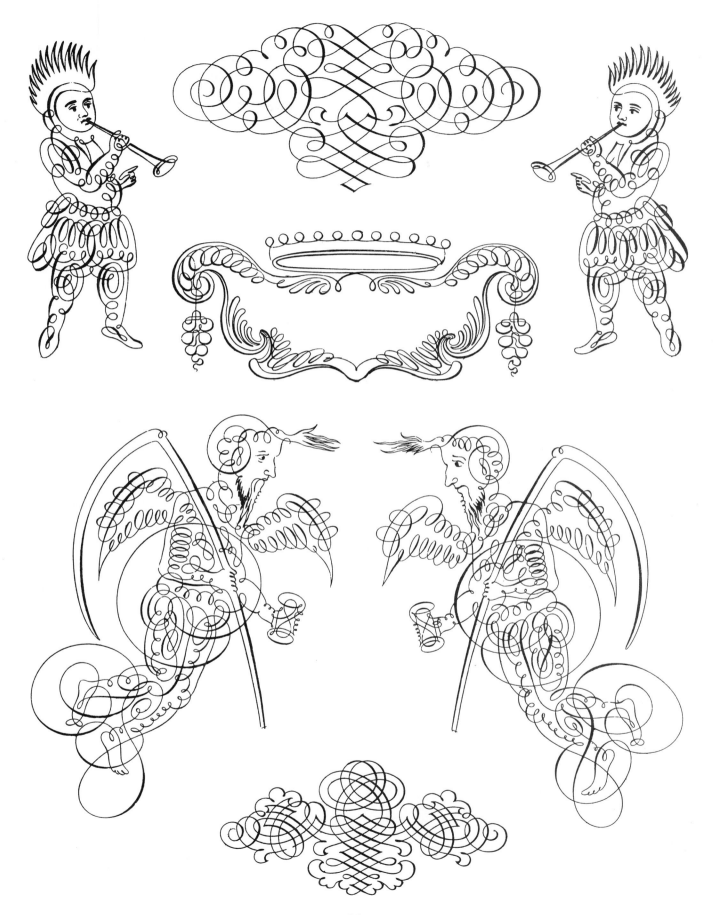

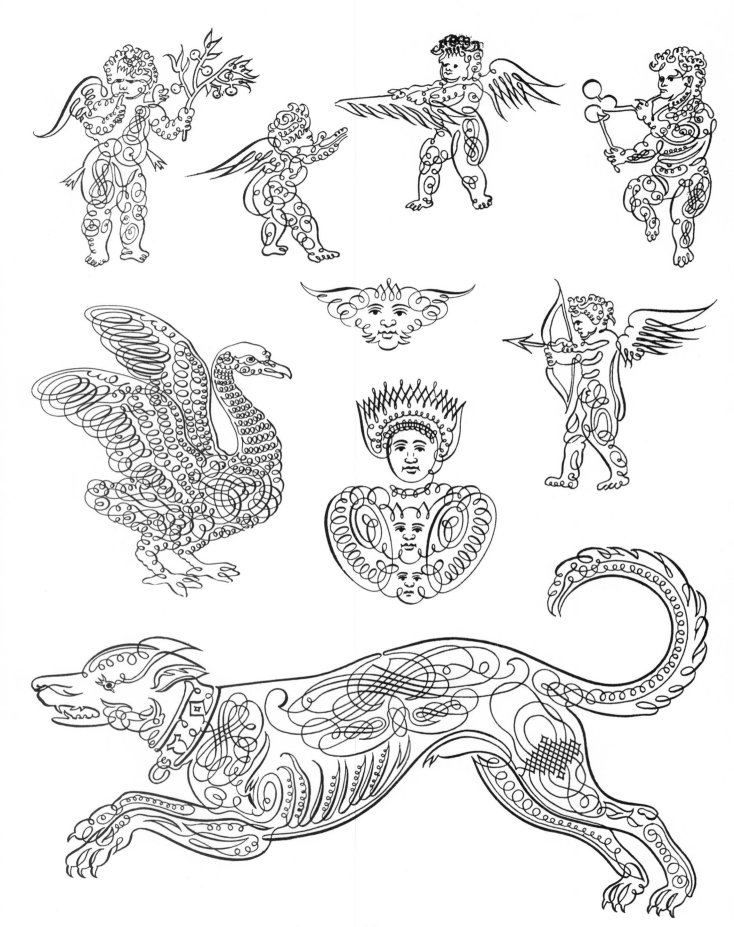

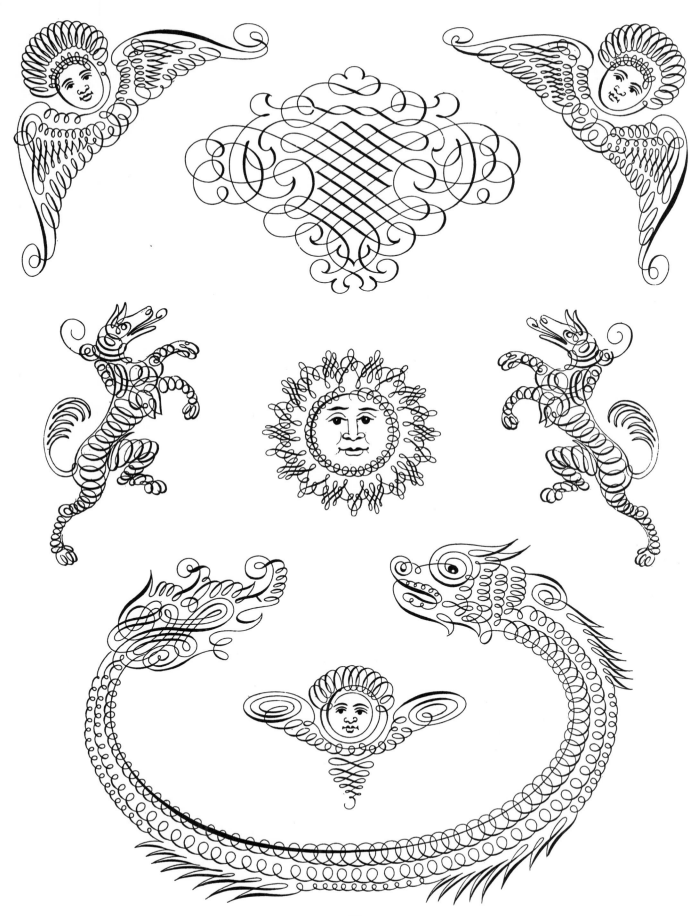

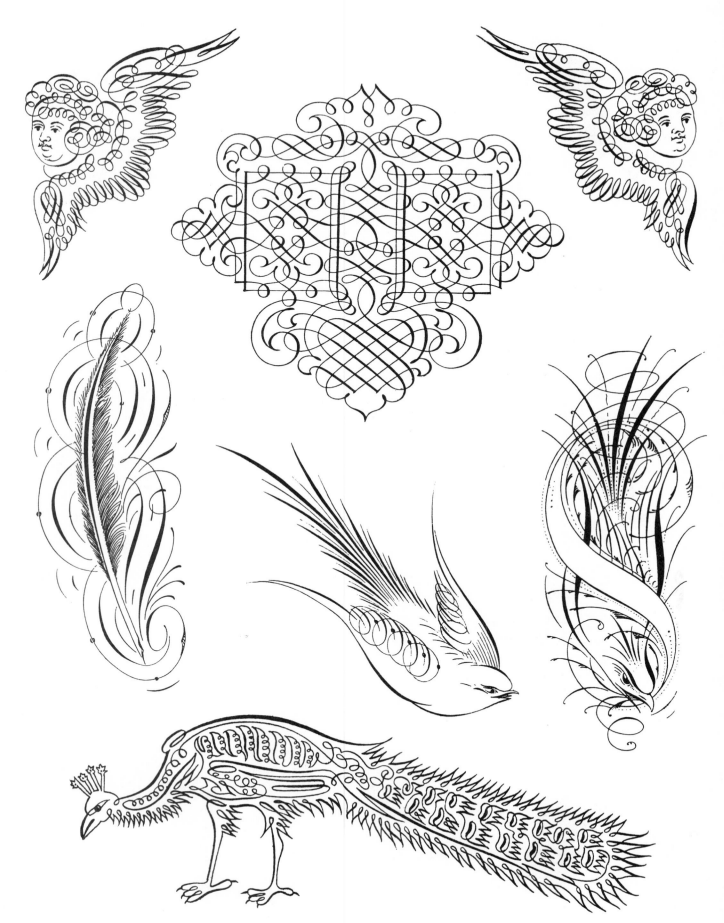

38

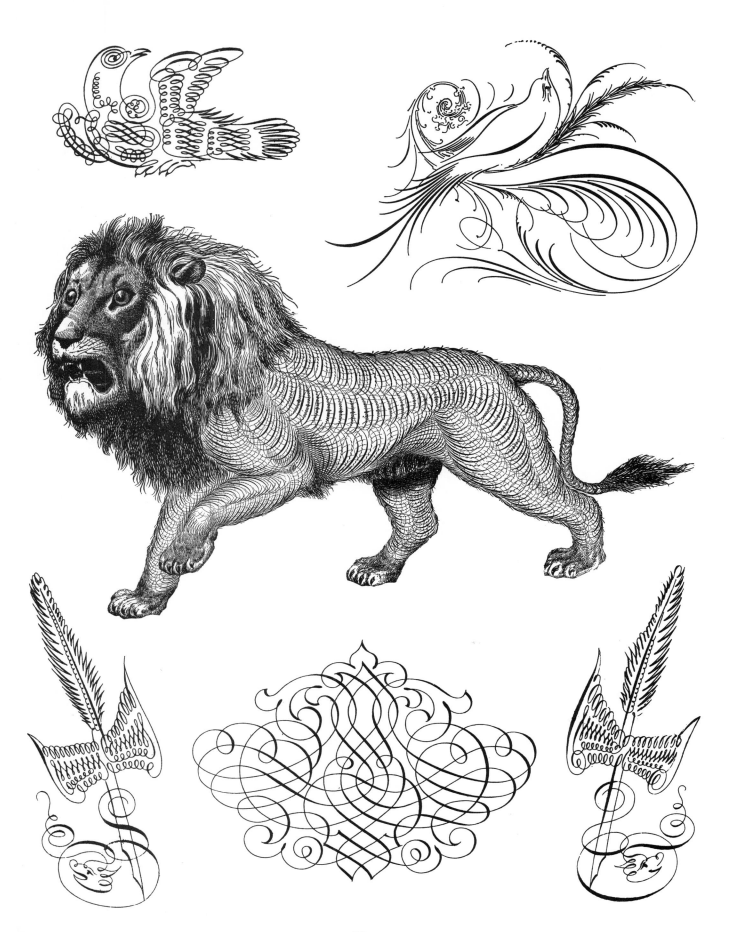

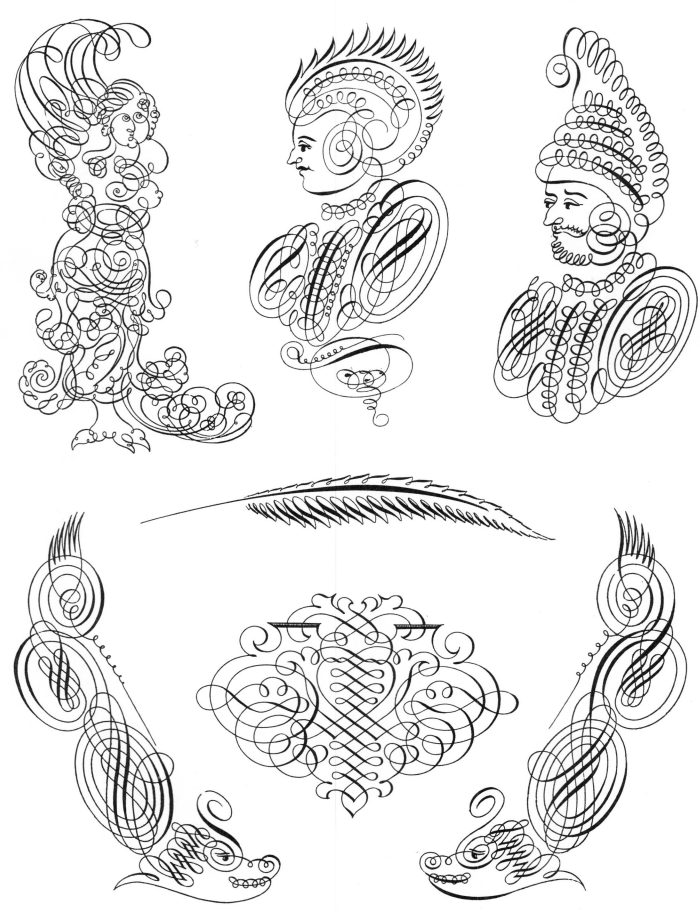

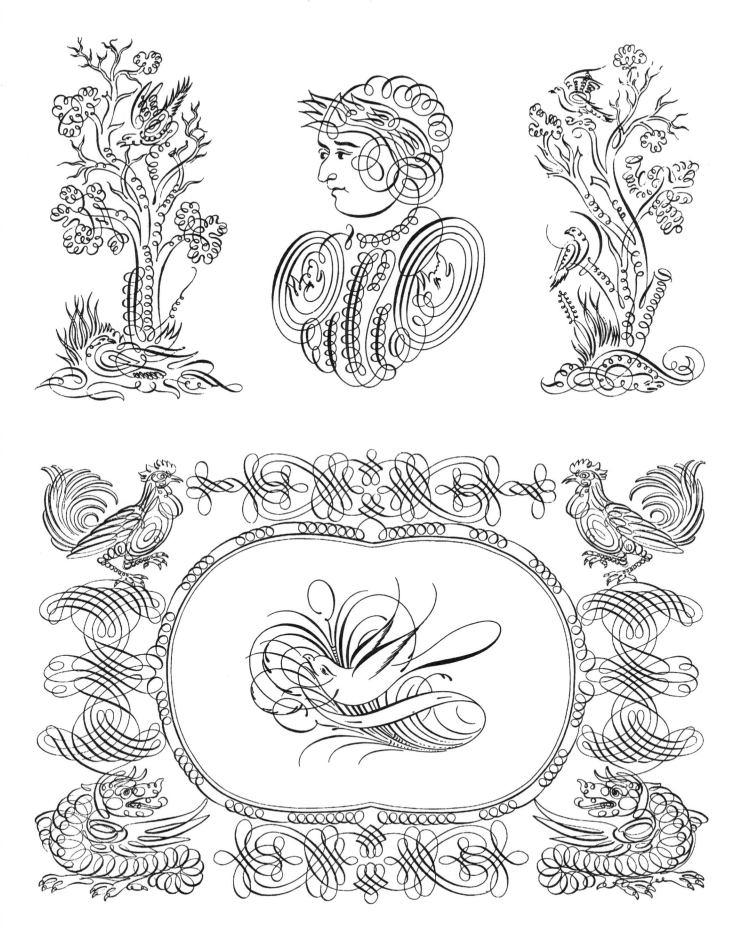

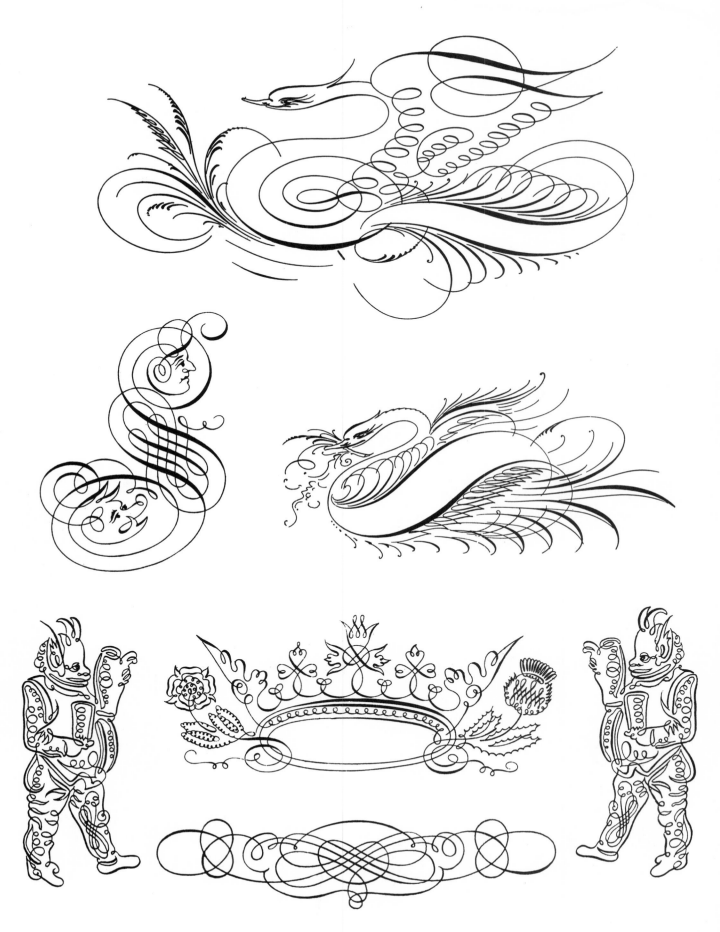

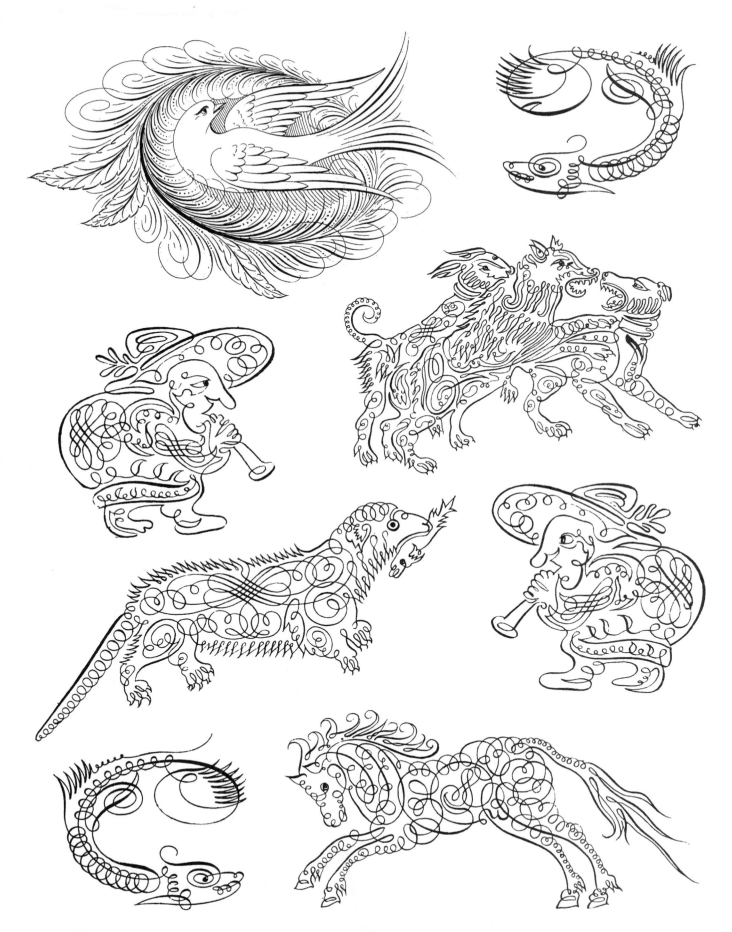